OUTHOUSES
of the WEST

A Firefly Book

Published by Firefly Books Ltd. 2000

First Printing

U.S. Cataloging-in-Publication Data
Hines, Sherman.
 Outhouses of the West / Sherman Hines ;
Silver Donald Cameron. –1st ed.
[72]p. : col. ill. ; cm.
Summary: Photographs with accompanying text
of outhouses in western U.S. and Canada.
ISBN 1-55209-523-1
1. Outhouses – Pictorial works. I. Cameron,
Silver Donald. II. Title.
973.9/09734 21 2000 CIP

Canadian Cataloguing in Publication Data
Hines, Sherman, 1941–
 Outhouses of the West

ISBN 1-55209-523-1

1. Outhouses – Prairie Provinces – Pictorial works.
2. Outhouses – West (U.S.) – Pictorial works.
I. Cameron, Silver Donald, 1937– . II. Title.

TD775.H56 2000 728'.9 C00-930779-6

Published in Canada in 2000 by
Firefly Books Ltd.
3680 Victoria Park Avenue
Willowdale, Ontario M2H 3K1

Published in the United States in 2000 by
Firefly Books (U.S.) Inc.
P.O. Box 1338, Ellicott Station
Buffalo, New York 14205

Design by Interrobang Graphic Design Inc.
Printed and bound in Canada by Friesens, Altona, Manitoba

*The Publisher acknowledges the financial support of the
Government of Canada through the Book Publishing Industry
Development Program for its publishing activities.*

OUTHOUSES
of the WEST

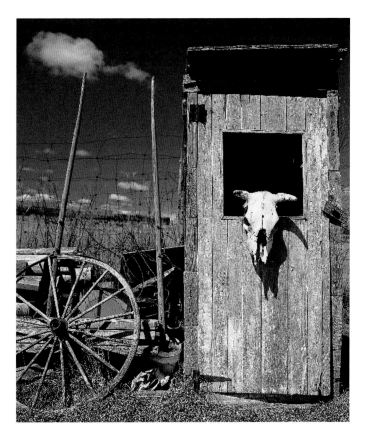

photographs by Sherman Hines
text: Silver Donald Cameron

FIREFLY BOOKS

Dedicated to Westerners everywhere who, in the midst of pioneering labor, still take time for moments of contemplation.

Outhouses of the West is not just a book of photographs. It is actually a profound meditation on the noble old theme of the vanity of human wishes.

This book is about the lusty, roistering, rammish society which has dug deep into the fecund earth of Western North America. It is about culture and architecture, about moments of contemplation in the midst of strenuous pioneering labor.

But it is also a threnody of sorrow, a mystical and nostalgic book. The outhouse, for all its many charms, has gone the way of scatomancy and the mail-order catalog, with which it had such a long and intimate relationship. All is mutability, transient as methane on the breeze. As the poet Yeats put it, "All things fall and are built again." Sherman Hines' brilliant images capture for posterity the unique quality of things which have fallen, and evoke the rich character and essence of others which have yet to fall.

On a more sociopolitical level, *Outhouses of the West* is a gesture of reconciliation and restitution—a gesture of fellowship from an Easterner to the West.

Many readers will recall that Sherman Hines' earlier researches ripened into the now-classic monograph *Outhouses of the East*. That volume, alas, erupted as something of a shock in the consciousnesses of many Westerners, who had believed, prior to its publication, that the outhouse was their very own, a classic embodiment of Early Settler (or Setter) architecture, the sturdy and inspirational Little House on the Prairie.

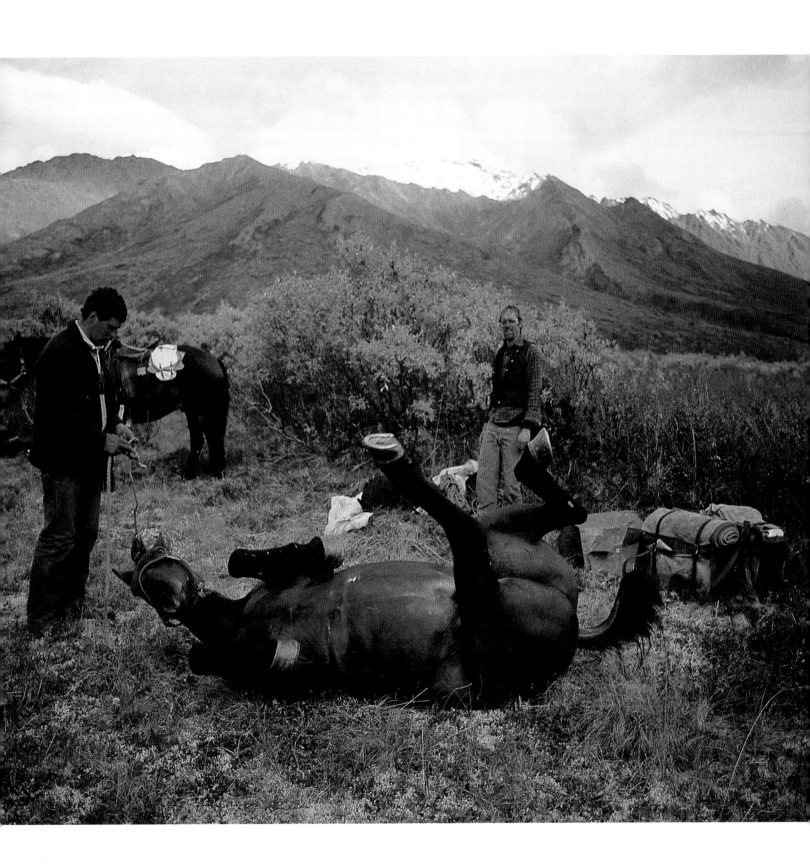

To Westerners, the outhouse had always seemed a fitting memorial to the ingenuity and practicality of their founders, those restless, imaginative spirits who first caught the scent of opportunity in the Western breeze. Placing the effete, deodorized, decaffeinated East firmly behind them, those early settlers propelled themselves through the limitless wildernesses of the Western plains and forests, fertilizing the wetlands, grappling with the river bottoms, irrigating the badlands and establishing the fundamentals of the Western gas industry.

The Western outhouse was, symbolically, the seat of government: the place where the equality of all people was perceptible and indeed undeniable. The outhouse expressed the open character of Western society, its impatience with secrecy and restraint. The development of four, five and even six-holed models became the architectural expression of the frontier spirit, people moving collectively to defeat the storms which howled around their sanctuaries.

The outhouse was the Yukon Trail, the Golden Gate, the sequoia. A defining image of West Marlboro Country.

Then along came Sherman Hines with his visual studies of beautifully tooled East Coast backhouses, so redolent of the Atlantic rollers. The book, alas, put all the cowhands in a flap. Westerners are weary of hearing that their whole society is, at bottom, derived from Eastern roots. To them, glory stories of the fisherman's biffy seemed worse than cheeky. Sherman's book struck them as a bum rap.

Western alienation always puts Sherman in a carminative mood, and—immersing himself in the project—he scatted for the West, camera in hand. Through the snow and hail he traveled, over endless highways and logging trails, seeking out and capturing forever this vanishing fragment of heritage.

He offers Western readers the result: this superlative monument to bygone borborygm. Take a contemplative moment to remember what once was, and to enjoy its memorial.

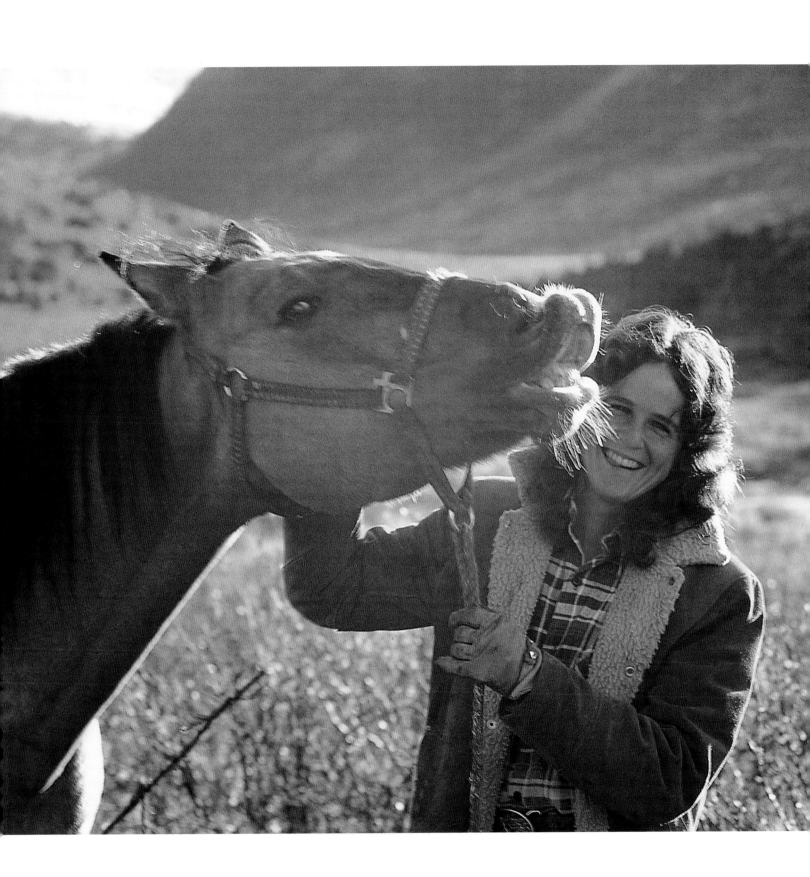

The Bold Farmer. A few broad western boards, plus wide-sweeping strap hinges and a bold slash cut through the doorway—more a scimitar than a crescent moon—and the convenience stands before us, solidly based as the distant barn itself. Today, years later, the profuse foliage attests to the facility's fruitful long-term environmental impact.

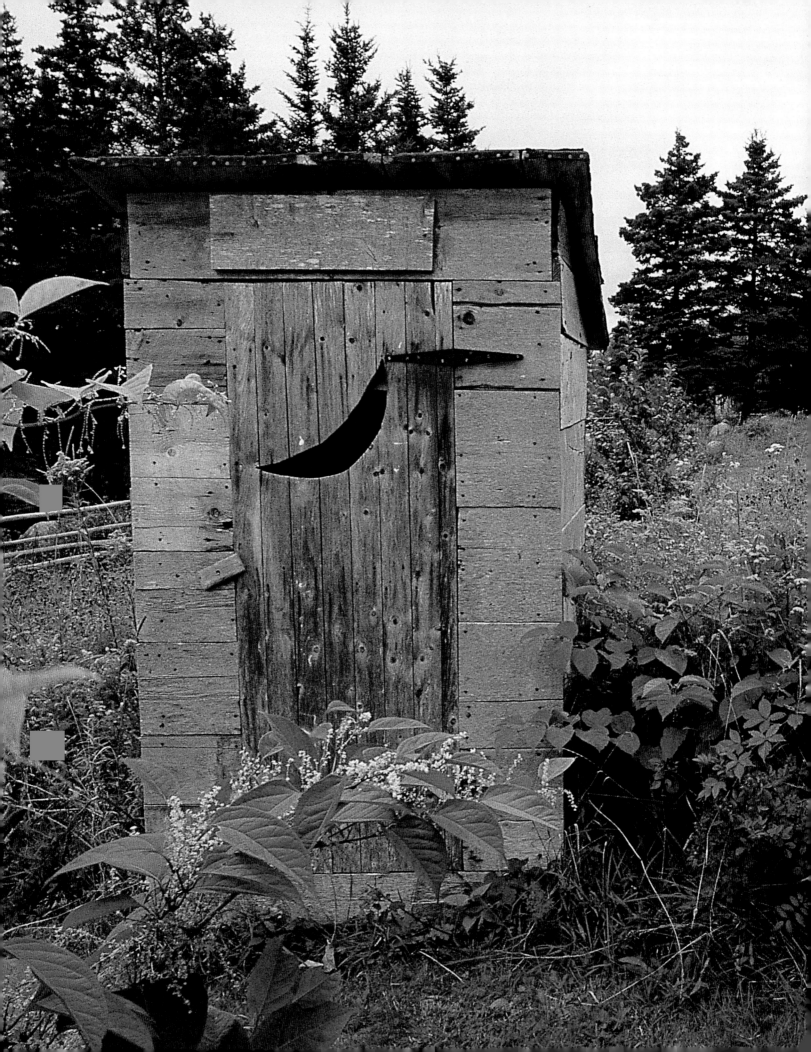

Early Highrise in Sagebrush Country. Drops of molten lead, when allowed to fall from a great height, become perfectly round shotgun pellets. The second-story approach, over a finely detailed catwalk, suggests that some similar technological benefit may be sought here, although a solid railing also permits ground-floor tenants to enter at their own level and perhaps at their own risk. Notice the aesthetic touches: the stack which echoes the shape of the main structure, and the climbing vines which in summer make a sylvan bower of this noble tower.

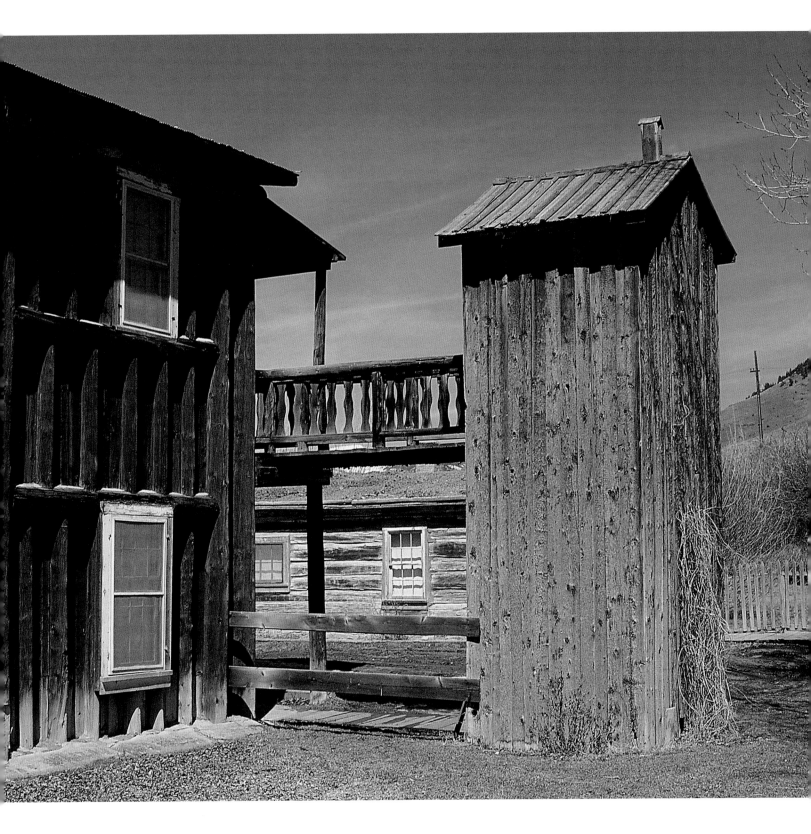

Bandido's Half-moon Hideout. Almost low enough to be concealed by the shrubbery, painted red to blend with the surrounding brush, this low-slung flat-top aims to be inconspicuous. But the slight tilt and the wedge-shaped opening at the bottom give the game away: the biffy is hinged on the left, and the loot is concealed under the seat.

14

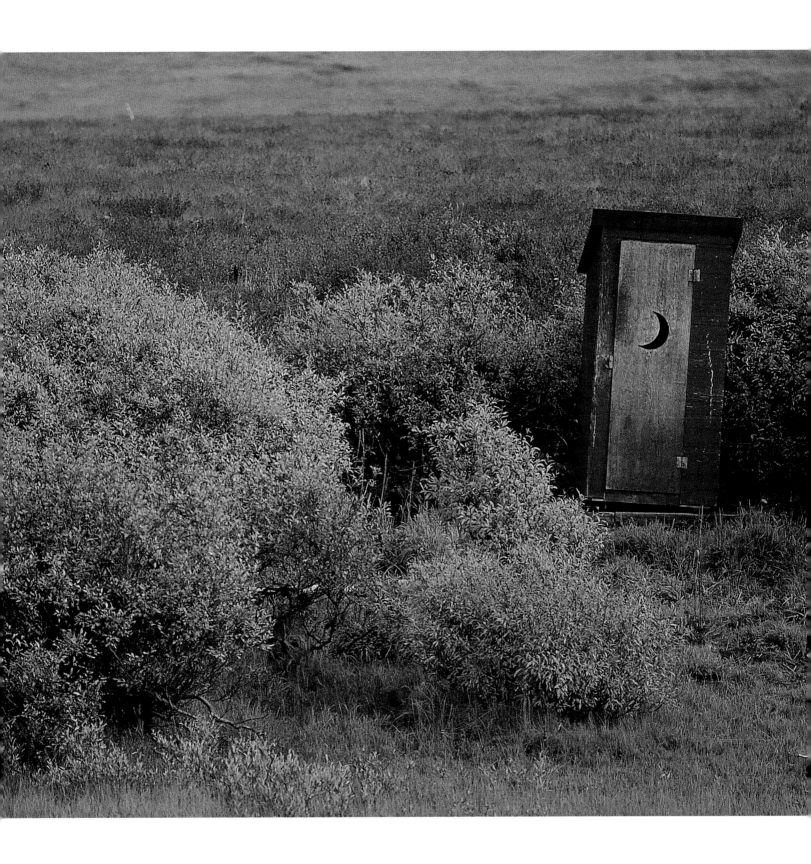

California Post-and-Beam. Casual and communal in its spirit, open to the influences of nature, minimalist in construction, this structure perfectly captures the existential uncertainty at the heart of the Big Sur sensibility. Note the ecological consciousness evidenced by the recycling of material even in the seat and the splash guard.

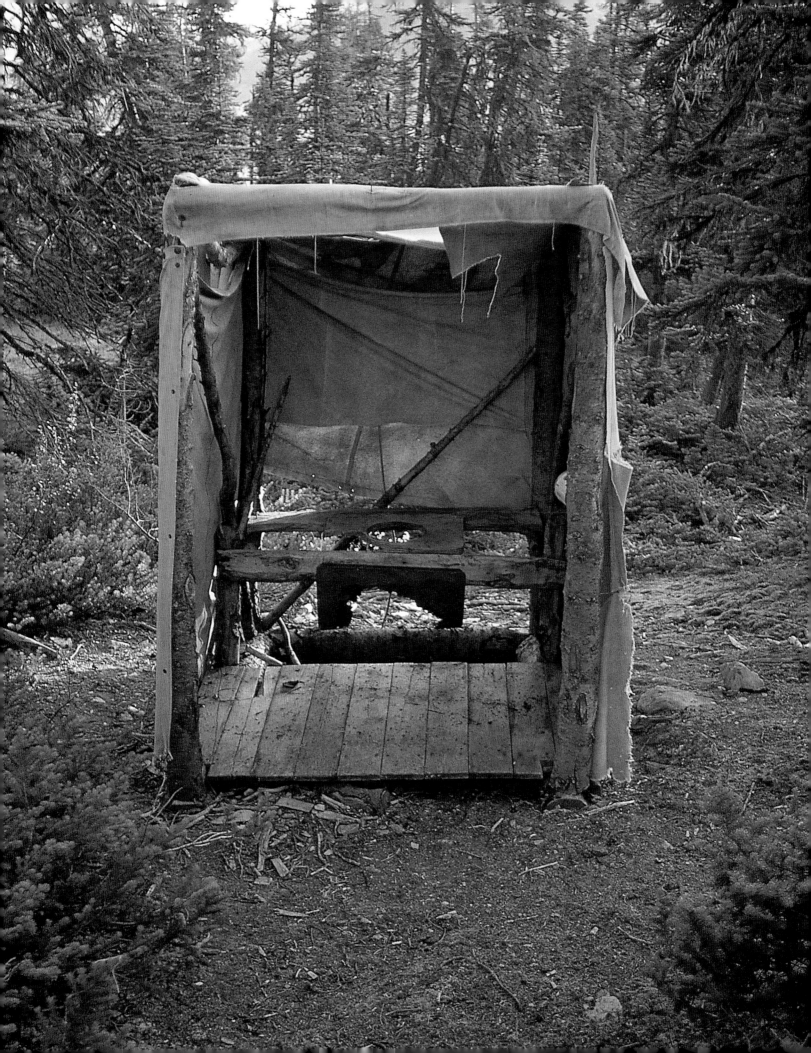

The Trapper-Crapper. Solid log construction, sturdy, traditional, reliable and charming. A certain aesthetic cachet issues from the skillfully proportioned logs, so nicely matched to the scale of the building itself—and, at this moment, the T-C bears an evanescent crown, a shapely nun's cowl of snow. In the depths of winter, though, with its unchinked interstices, the Trapper-Crapper is not a place to linger longer than need requires.

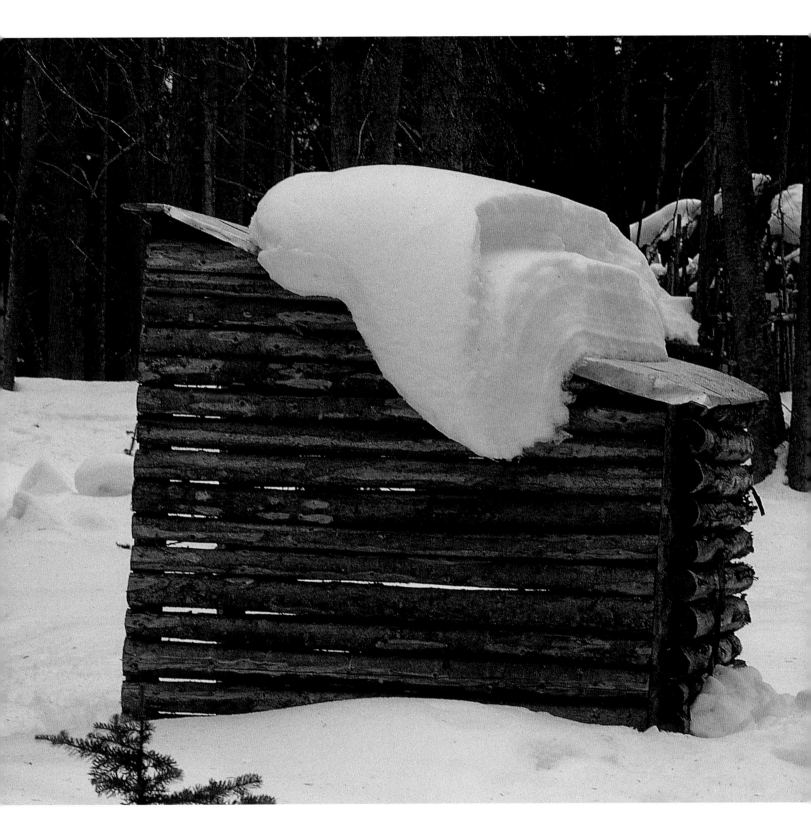

The Bear Minimum. A jaunty gent, high on the edge of the mountain scree, attends the call of nature in perfect modesty while retaining his vigilance. No eagle, bear or mountain lion can approach him unnoticed, while his rear is perfectly covered by the only sheet of plywood in miles. In its insouciant tension between concealment and revelation, between the individual and the communal, this alpine shelter profoundly resembles the cosmopolitan pissoirs of the Parisian boulevards.

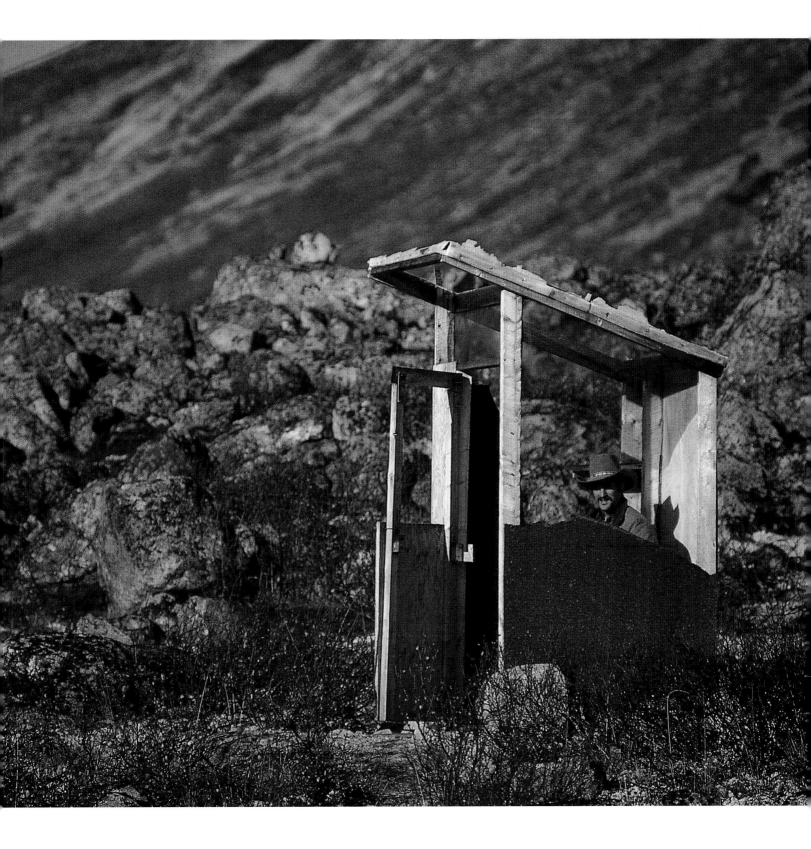

As our story opens, Black Bart and his faithful cayuse Fumet move cautiously through the wintry wasteland—exhausted, but not yet certain they have not been followed. Behind them lie a shocked community, a weeping wife, a dying father. But is this a sanctuary in the mist? Is relief at hand?

While Fumet takes a well-earned rest, and Bart's guard is down, Nevada Ned rides in, astride Trocar. He recognizes Fumet at once, and swaggers into the building, taking in the whole interior with a single penetrating glance. "So!" cries Nevada Ned. "This is the showdown!"

The tranquil postures of Trocar and Fumet in no way reflect the intense struggle, the tragedy, being enacted only a few yards away. A single sharp report shatters the clean, cold Western air. A cry of anguish sails across the frosty bushes. Then the eternal silence of the lonely landscape falls again.

Fumet stands alone in the silent landscape, wondering where his next meal is coming from. Nevada Ned and Trocar are gone and all that remains is the sanctuary—and the stiff, silent figure sprawled inside it.

Black Bart's Death Camp National Historic Site. A frightfully accurate reconstruction erected by Parks Canada in Wolf Scat National Park at a cost of $12 million.

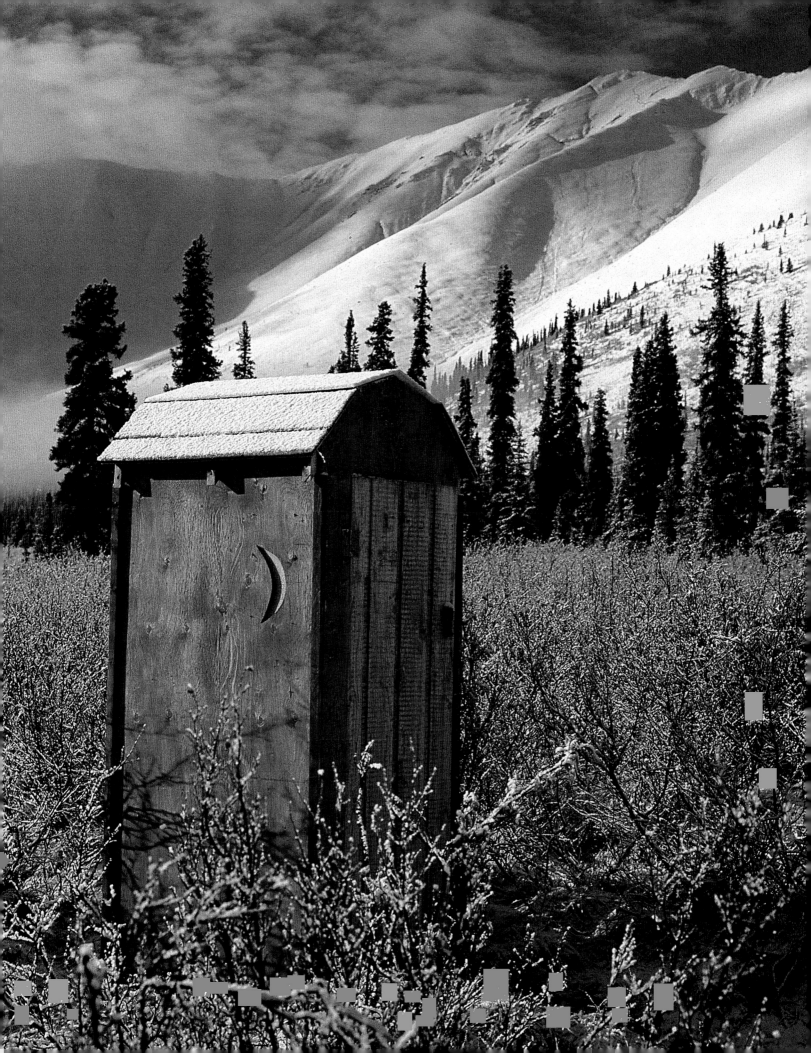

The Leaning Tower. This unique specimen was built jointly by a Yukoner and a New Englander, mortal enemies united by a common need. The New Englander built the face of the building and the right side, using traditional Down East techniques and materials: shingles right out to the corner, and a Cape Cod roof line with no eaves. The Yukoner simply slapped up slabs on his side of the building, but inexplicably went to the needless trouble of full-scale corner boards. The two builders could not agree on how to read the spirit level, either, so the building remains level only in spirit.

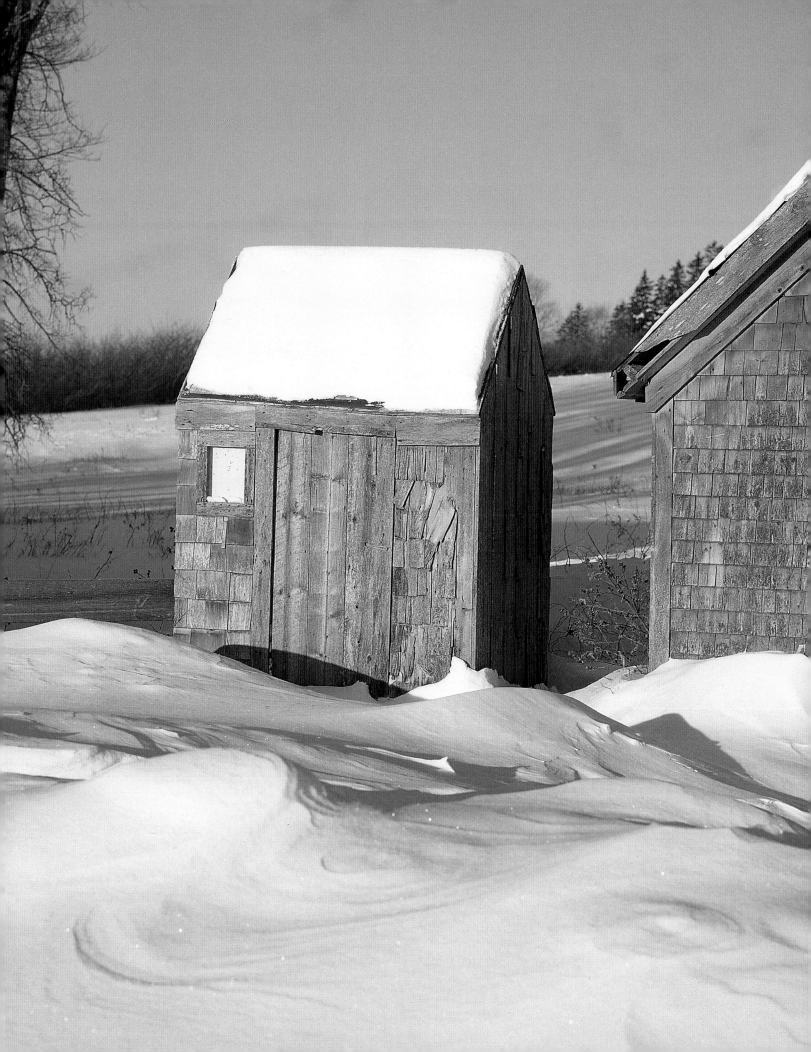

Hamlet's Head. An outhouse unable to decide its own destiny, this solid little building looks permanently rooted, with its mossy roof and firm attachment to a straight new fence. It sits on a permanent base of concrete and brick, testimony to the determination of a settler to remain on this rock-strewn and rather unpromising homestead. But notice that the building rests on heavy creosote skids, while a tow-rope lies half-buried in the snow to the left. If the crop is no better next year, by golly…

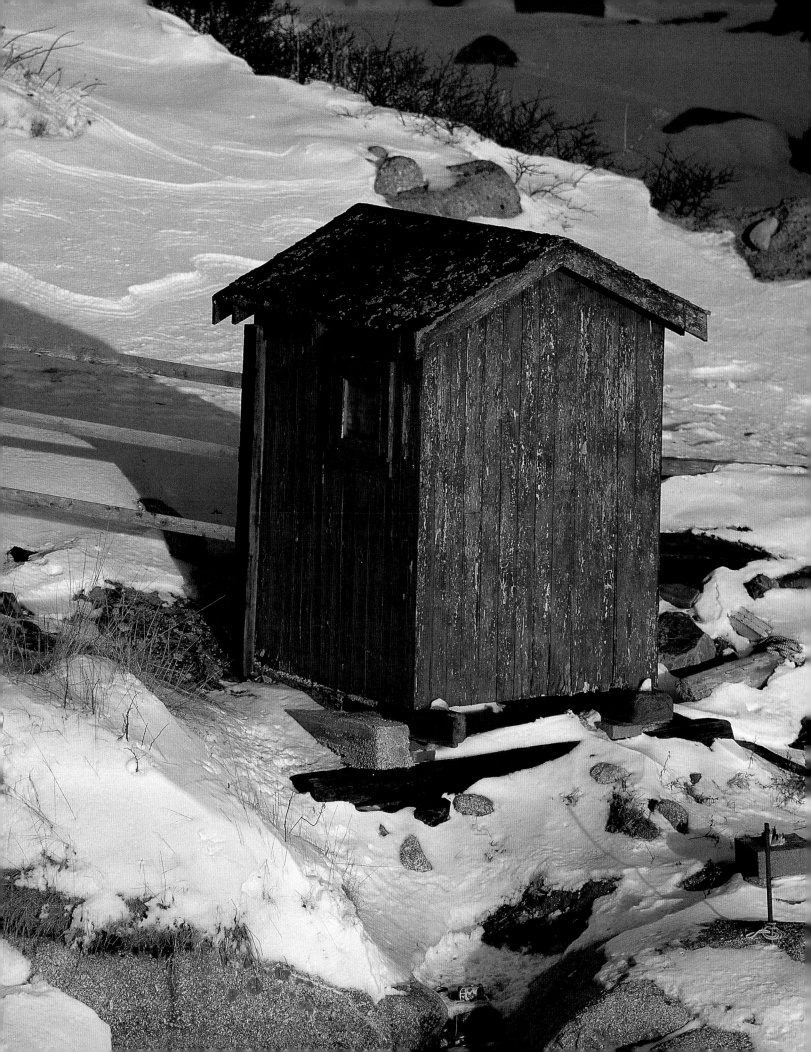

The Deacon's Masterpiece. This Prairie jewel was built by Frank Merriwell, a Deacon in the Fundamental Covenant congregation of Lotus, Saskatchewan. A firm believer in Doing It Right, the Deacon sired 13 children, and built his outhouse to accommodate the early morning lineup under the cover of a sheltering porch. Note the notched corners, the cement chinking, the muscular hinges, the husky thumb latch. The work is well done in every particular, and provided the Merriwells with a still, silent spot in the middle of the Prairie winter. Indeed, the Deaconess remarked more than once that she wished the main house were as well built as the s*** house. (She was of Czech ancestry, so the asterisks in the word are sounded.)

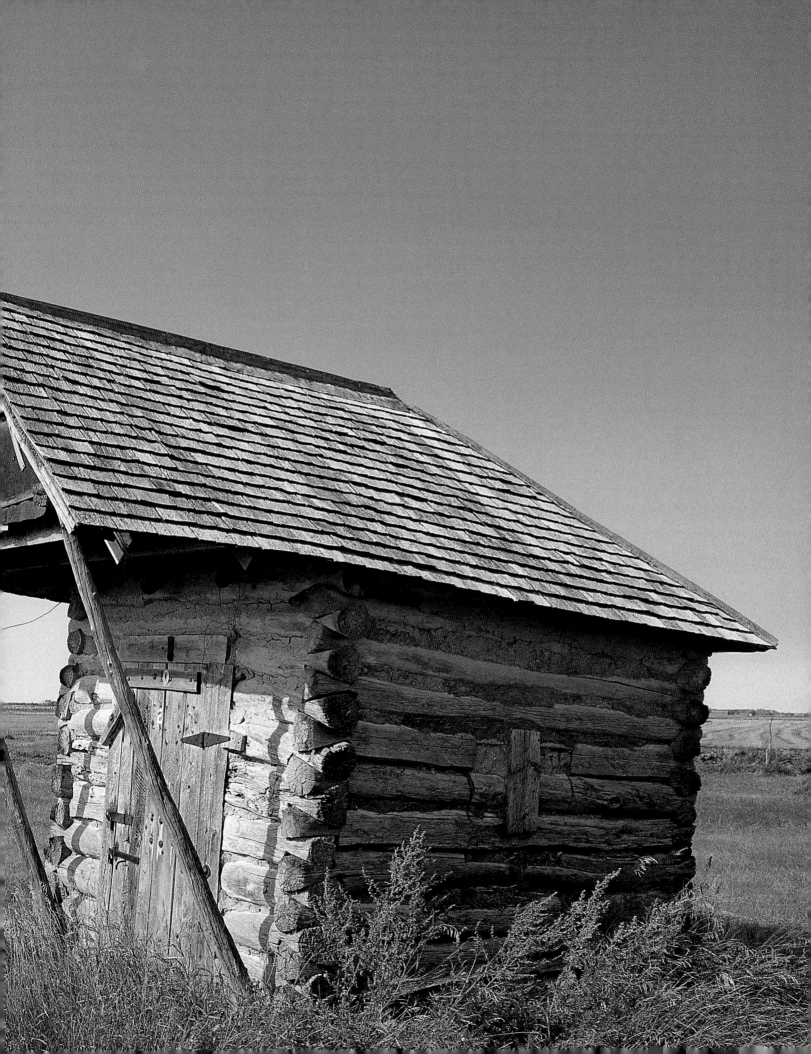

The Bau/out/haus. Stark and imposing in its lines, functional in its sheltering overhangs, warm in its dark brown color and challenging in the subtle interplay of its textures, this little gem is beautifully set off by the lush, fluffy, rounded shapes of the fresh snow. The bold, arrow-like configuration of the rafters, which make the roof look like a surface-to-wind missile on the verge of launching, has drawn much admiration from students of modern architecture.

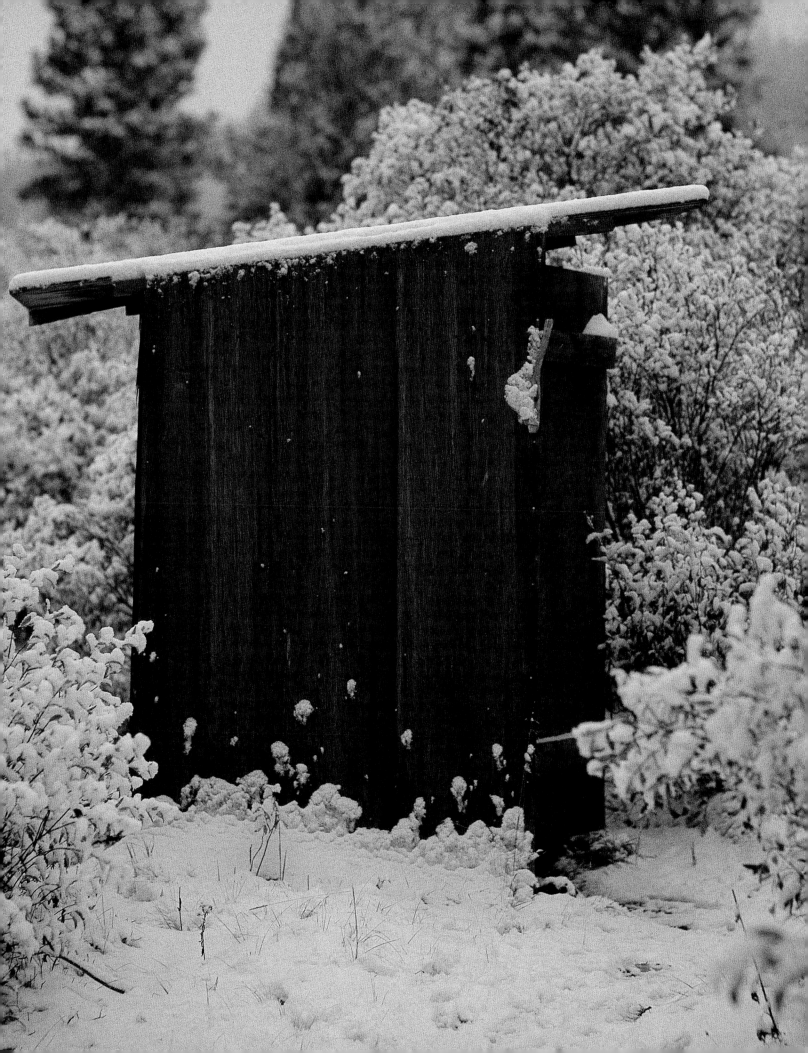

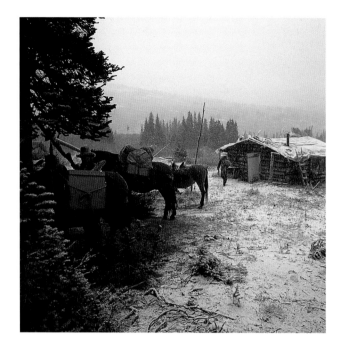

Northern Comfort. It is hard to know what one admires more—the site, the setting, or the magnificent composition of the photograph itself. The well-beaten trail through the deep snow (aided, if need be, by the shovel in the background) speaks of a winter spent in philosophic contemplation and pleasant reading, broken only by occasional treks to the outhouse. A fine, hermitic lifestyle. The oil can in the foreground suggests that this may be one of those surprising rarities: a centrally heated biffy.

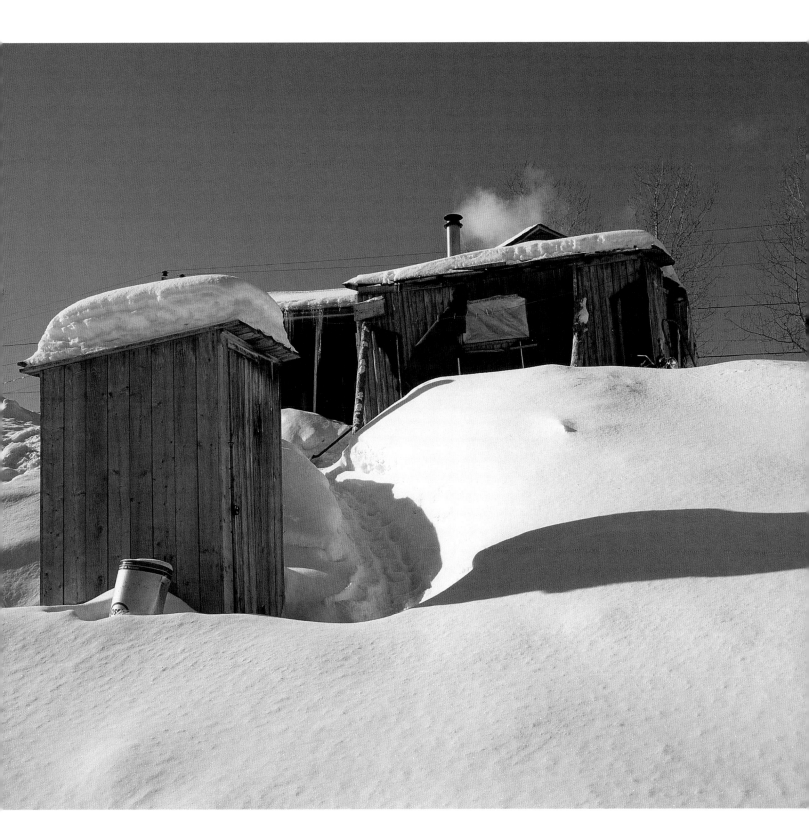

The Cherry Tree Special. My favorite Western outhouse story came from a United Church minister in New Denver, British Columbia, during the puritan depths of the 1950s. It concerns an outhouse which straddled a brawling mountain creek—a classic Rocky Mountain design of which this is one of the few examples extant. But the outhouse toppled into the creek and was swept away. Its owner accosted his young son angrily. "No, Daddy," the son protested, "I didn't." "Son," said the father reassuringly, "let me tell you the story of George Washington and the cherry tree… Now, let me ask you again: Did you push the outhouse into the creek?" "I cannot tell a lie," the little fellow nodded sturdily, "I did push that outhouse into that creek." The father instantly laid violent hands on him and gave him a tanning fit to make a quarter horse whimper, while the son wailed at the unfairness of it all. "George Washington told the truth, and his father didn't even give him a licking!" he protested. "True," said the father, with a grim smile. "But let me explain the difference. George Washington's father was not in the cherry tree at the time."

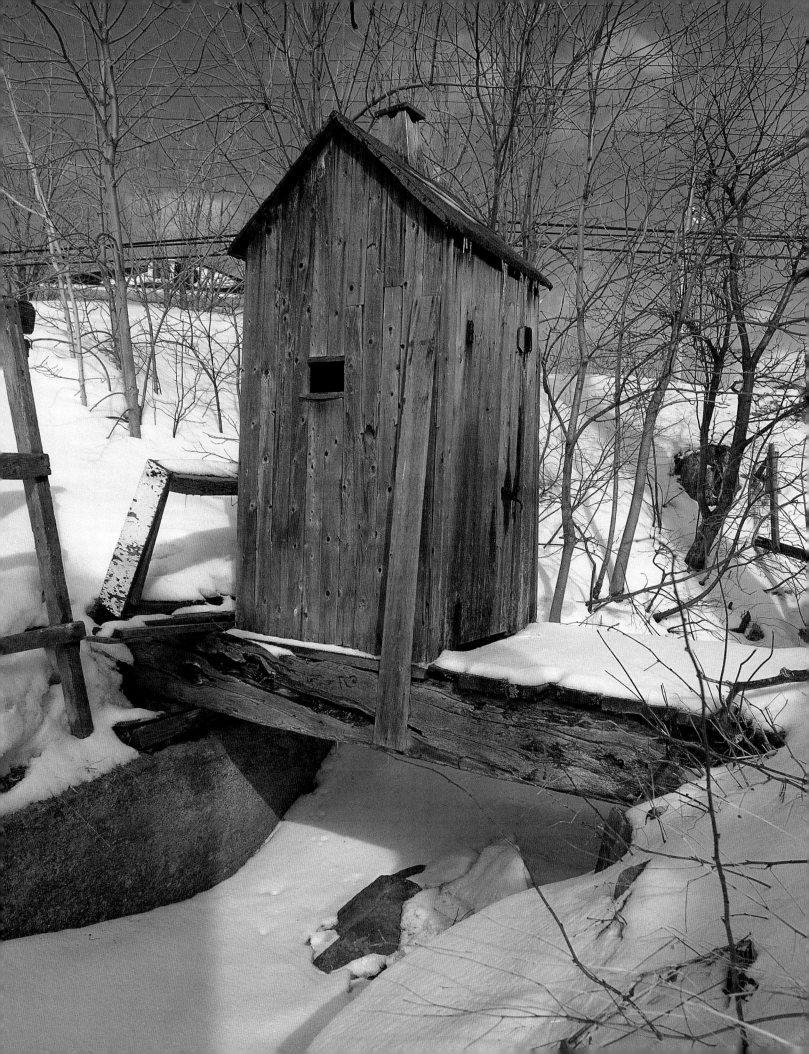

The Well-Tempered Outhouse. The homesteader of the 1970s and 1980s considered his outhouse a temporary nuisance, soon to be replaced. But this outhouse is just the opposite: not a stopgap, but a permanent part of the establishment. It is actually incorrect to call this structure an outhouse at all; being wedded eternally to the house itself, it would more correctly be called an "on-house." No need here for a perilous pilgrimage through winter's drifts. And a good thing too, by the looks of things.

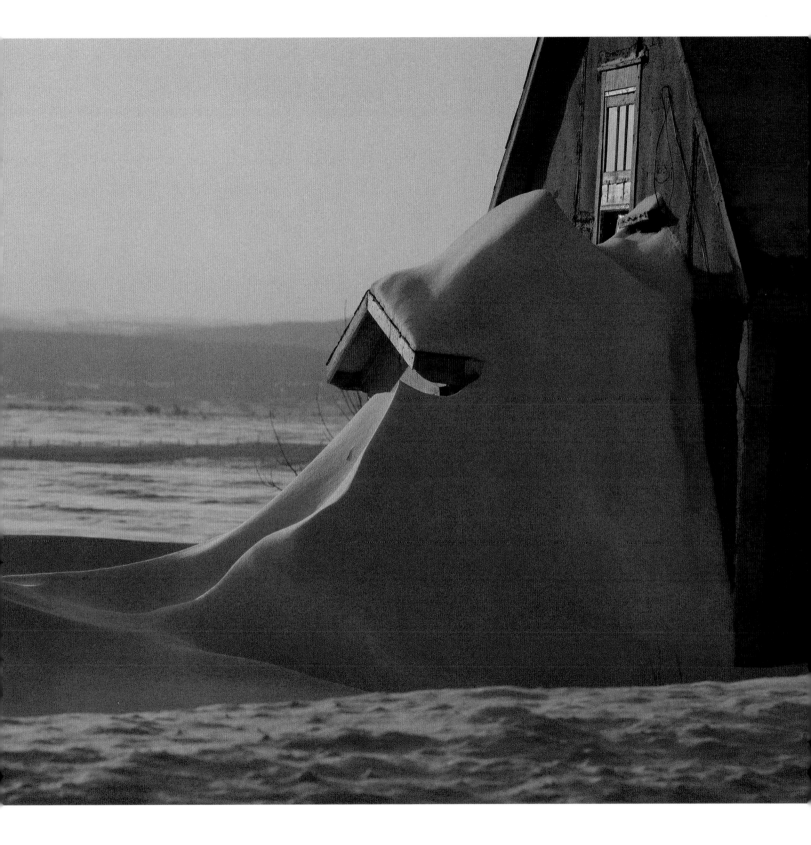

A Mixture of Artistries. The precise opposite of The Deacon's Masterpiece, this outhouse is the work of a devil-may-care artist who doesn't care two bronco-blasts for convention or practicality. His roof delivers the rain directly into the doorway—but who cares? The exuberant, joyful paint job —inside as well as out—is a statement of faith in Life and the Creator. And the Creator has responded with a magnificence of precipitation which must be received as a tribute of recognition to a fellow creative spirit.

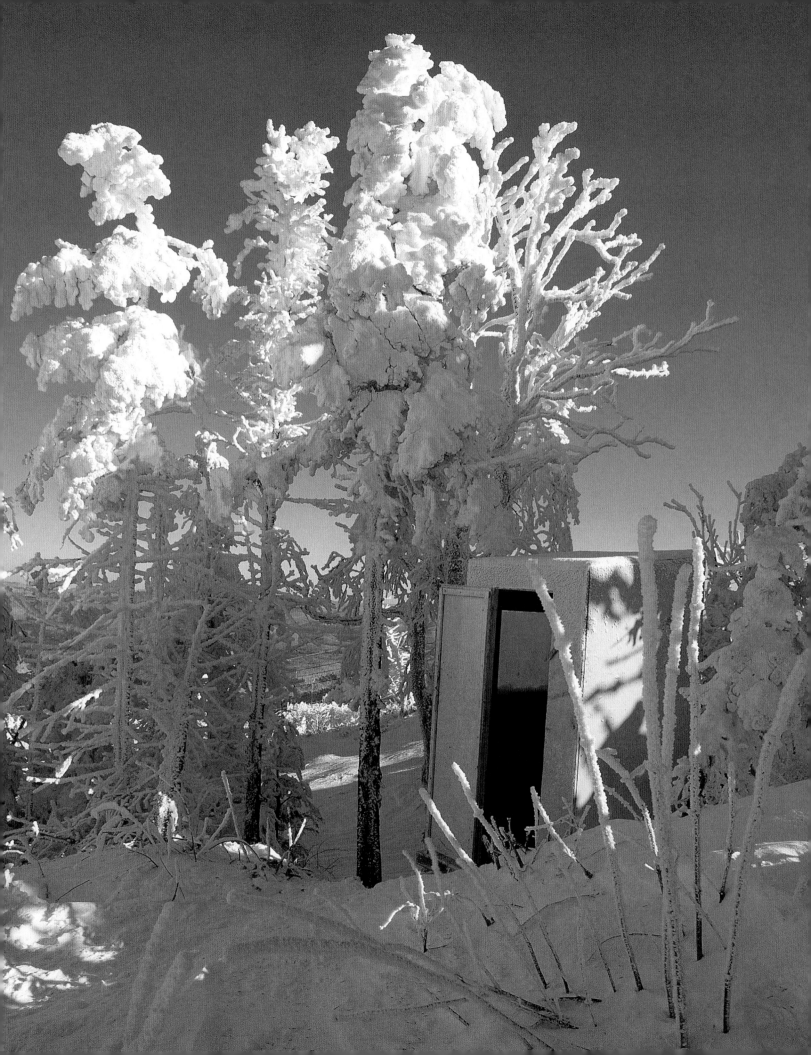

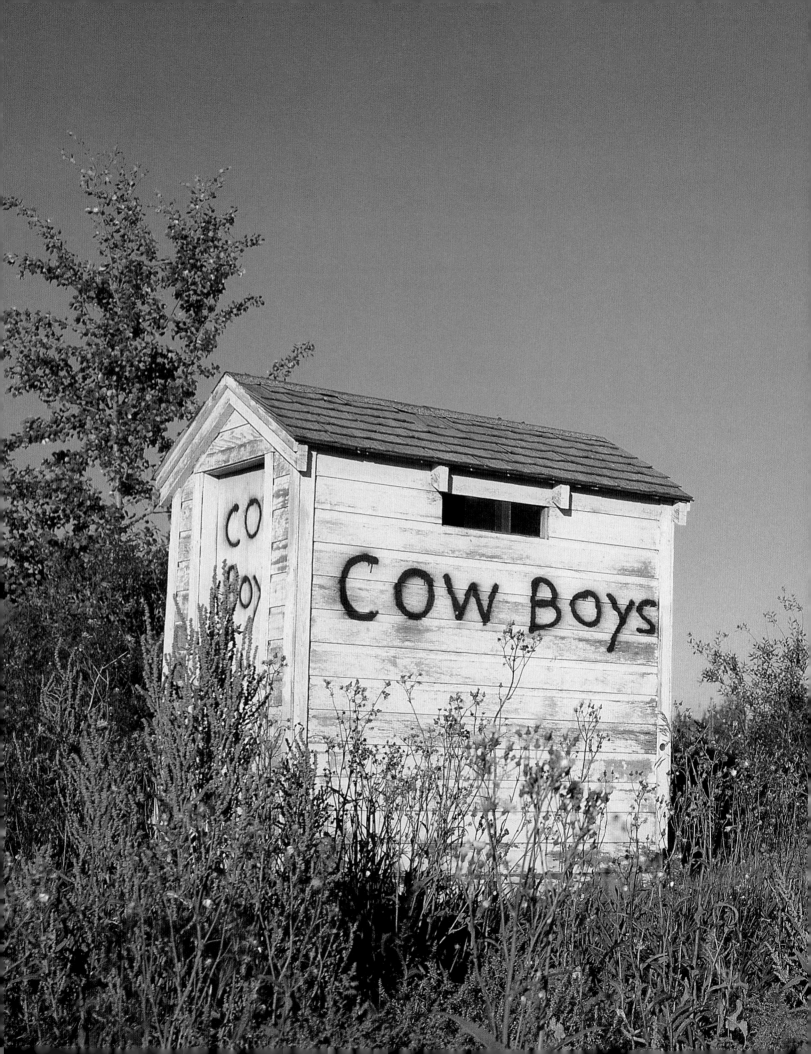

"Give me eastern trimmin's where women are women, in high silk hose and peek-a-boo clothes, and French perfume that rocks the room, and rings and things and buttons and bows…" So sang Jane Russell in the Bob Hope classic *The Paleface*, and—faced with this pointless discrimination in the alder bushes, this eruption of machismo in the land of equality—one is driven to agree with her. Doubly so when the lads have—as always—reserved the better biffy for themselves, relegating Jane Russell to a flat-roofed, unpainted plain-Jane box. But there was nothing plain or flat about Jane. No wonder she went East.

Wind-Powered Fertilizer Factory. One of the West's earliest attempts to break free of the Eastern industrial monopolies, this little plant produced enough fertilizer for half the township, employing a surprising number of people in production. Notice the windmill, which drove the assembly line, lifting the product up onto the wooden skips after which it was carefully loaded into the beefy trailer for delivery to neighboring farmers. (A piece of the conveyor system can be seen behind the pile of skips.) It went out of business after the Mulroney landslide, which produced a torrent of inexpensive product from Ottawa.

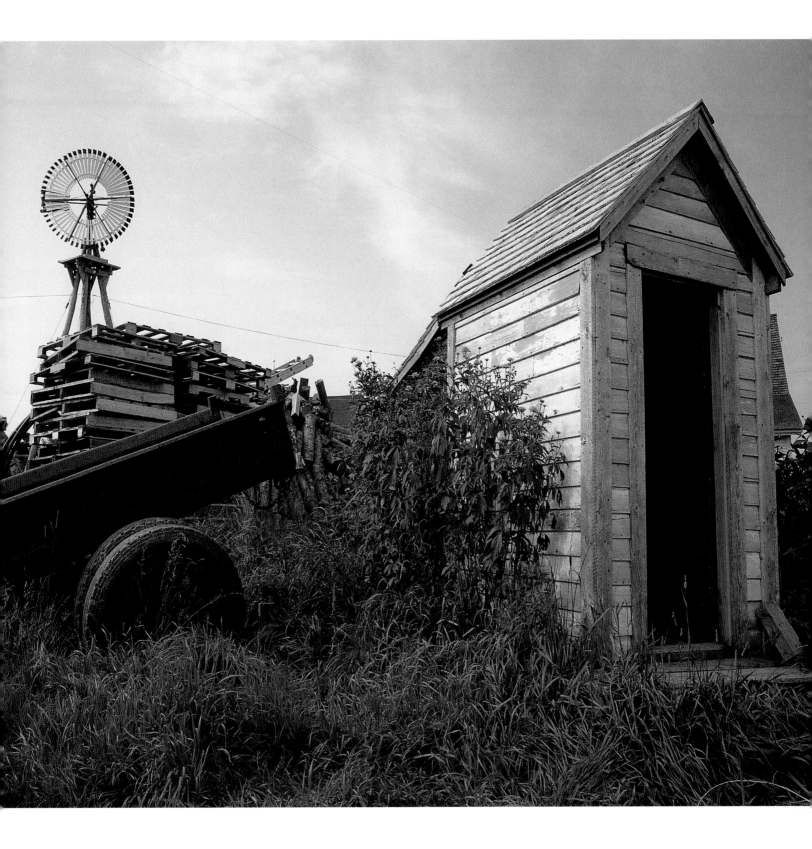

Custer's Outhouse. Extensively rebuilt since the tragedy, this otherwise unprepossessing building in the birches is the official memorial site of Custer's Last Sit. Ambushed while his rearguard was exposed, Diamond Jack Custer was riddled with bullets by police and federal agents, who were taking no chances. Only the board to the left of the door testifies to that fateful day; all other parts of the front were too badly holed to perform their function, and were replaced.

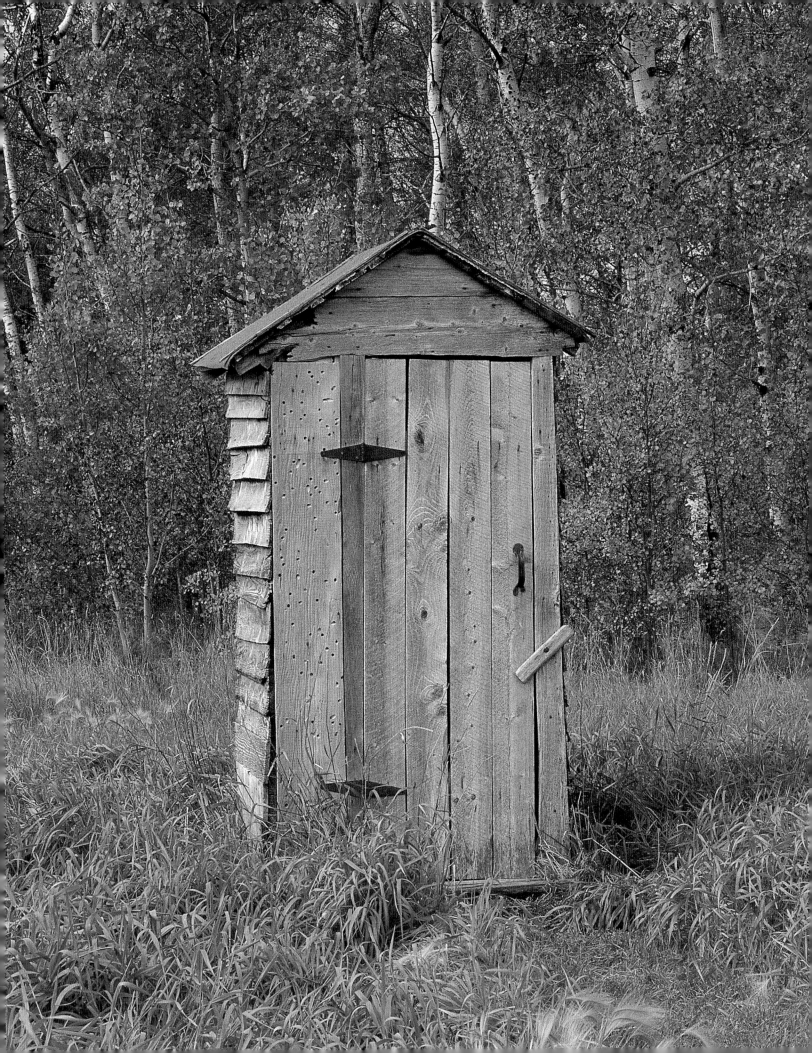

The Dew Drop Inn. Although its name is evidence of a serious attack of the quaints, this stylish little edifice offers a bold approach, fine detailing and a strong but dignified use of color. It was commissioned in the 1920s by the Duchess of Dogberry, whose family owned 7000 acres of the B.C. Interior. The Duchess was often heard to remark that she preferred to take tea in the company of her horses than in that of her husband. Fortunately, the Duke made no objection, being himself a celebrated beagle fancier.

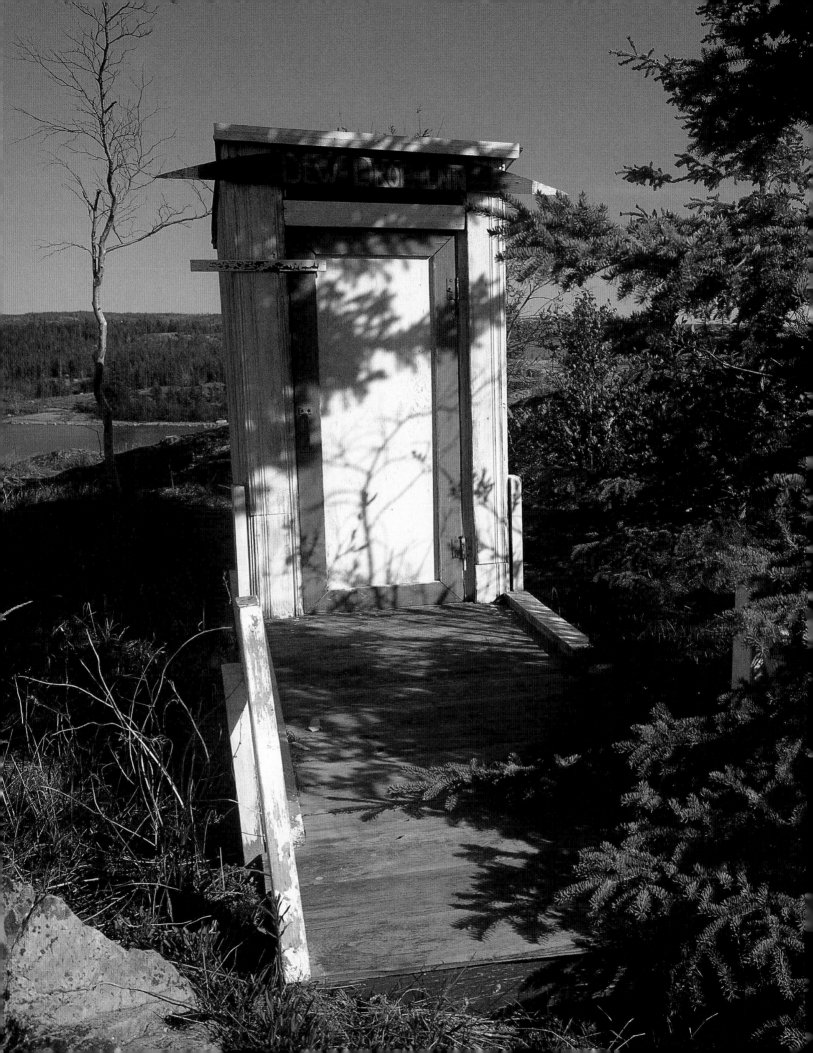

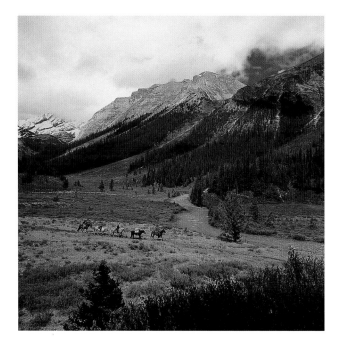

The W.O. Mitchell Outhouse. This well-built structure on the edge of a garden in the Alberta foothills holds a special place in the history of Canadian literature. During a meditation in this outhouse, Merna Mitchell was moved to recite some poetry aloud, and the lines of Christina Rossetti came into her mind: "Who has seen the wind? Neither you nor I…" Her husband, the celebrated author W.O. Mitchell, was planting red cabbage nearby, and replied, "Well, I ain't seen it, but I heard it just now." His masterful novel *What I Did on My Summer Convalescence* was a direct result of the ensuing discussion.

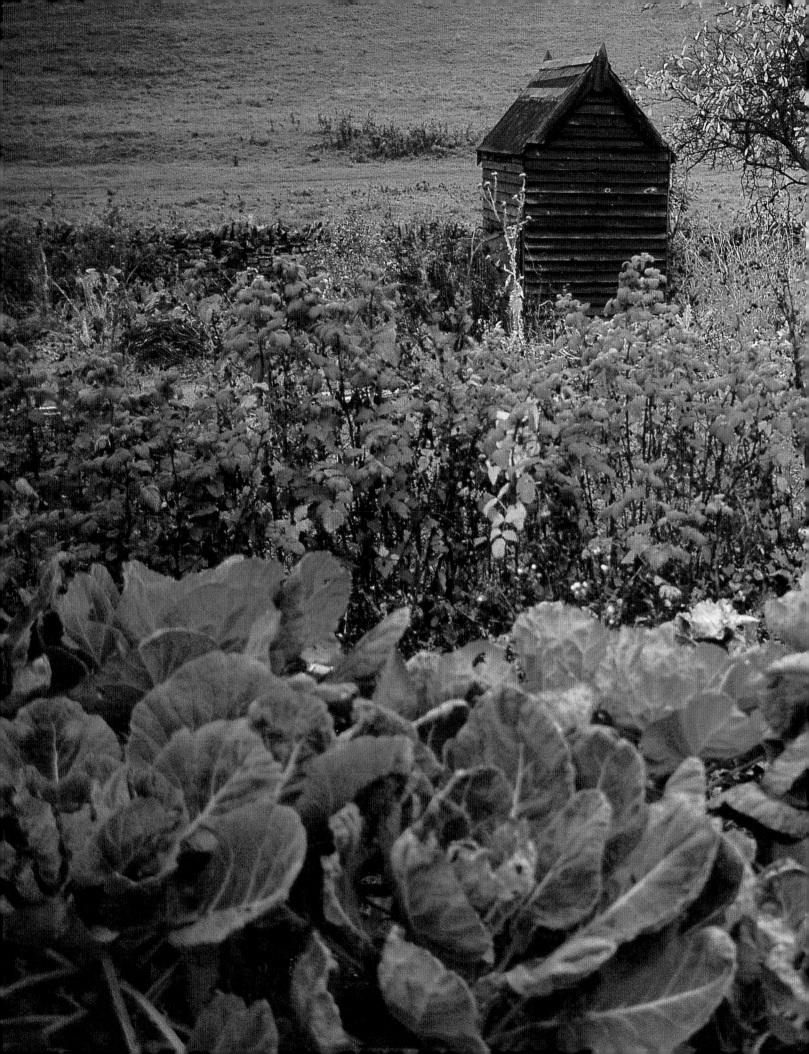

The Cosmic Can. Carefully placed
at the focus of a wide natural
parabola, stationed to concentrate
the cosmic flows of consciousness,
is a Divine Blind—like a duck blind,
but intended to trap marvels
rather than mallards. It may take
weeks to achieve satori—or sitori,
as the case may be. But in this
colossal setting, with only free-
ranging horses for company, the
California millenarian may
reasonably hope to achieve the
Transcendent Emptiness which is
the goal of so much mysticism.

The Hippie Hut. Back to Nature—but not close. The urban refugee buys his mountain acreage and installs his flimsy outhouse, a risible makeshift. Its quarter-inch plywood construction would move Deacon Merriwell to lofty contempt. The homesteader intended to remove it when he "got some bread together," hooked up the electricity and drilled a better well. Instead, he got his act together, looked around and left. Only the outhouse remains, one hinge already failed—the spoor of a romantic tenderfoot, mocked by the autumn splendor.

Grannie's Glory. She was no bigger than a minute, and Grandpa adored her. She was an educated woman from Back East, a graduate of the Teachers' College at Guelph, and she liked to read. It somehow seemed wrong to make her share with the hired hands, or to make the hired hands wait—for Grandpa was an equal opportunity employer in such matters. So he built her a little house of her own, facing east, with a nice south window to cast light on her book. She made the curtains herself. And now that they're both gone, what grandson can bring himself to tear down her decaying monument?

Amazing Grace. Here is style, quality and wit in an instant comfort station. The landscaping is so new and raw that the diesel exhaust of the dozers seems still to hang in the air, while plants and flowers have not yet mustered the courage to try again. Yet this building's nicely proportioned boards and battens, hand-split shakes, and insouciant, ironic signage announce a certain expectation of civility, a promise that there is indeed life after construction.

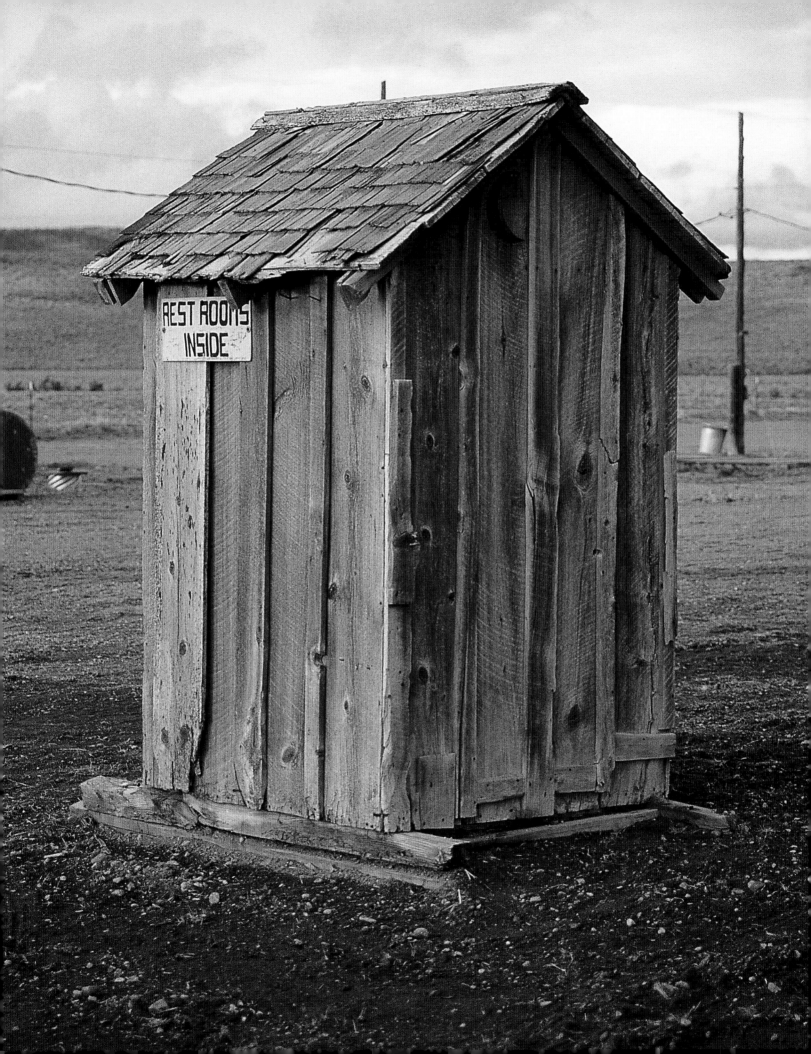

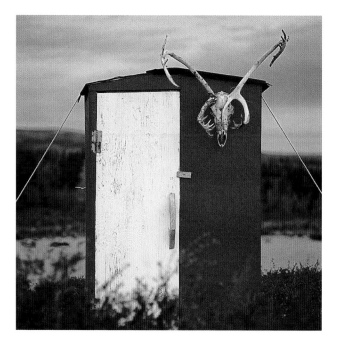

On the lonely prairie two small buildings proclaim the vanity of ruminant wishes. For a brief glorious interval, a buck stands tall, taut with testosterone, rampant and horny, master of the herd. But time and destiny nail even the proudest to the wall, proving—in the end—that male pride is a load of bull.

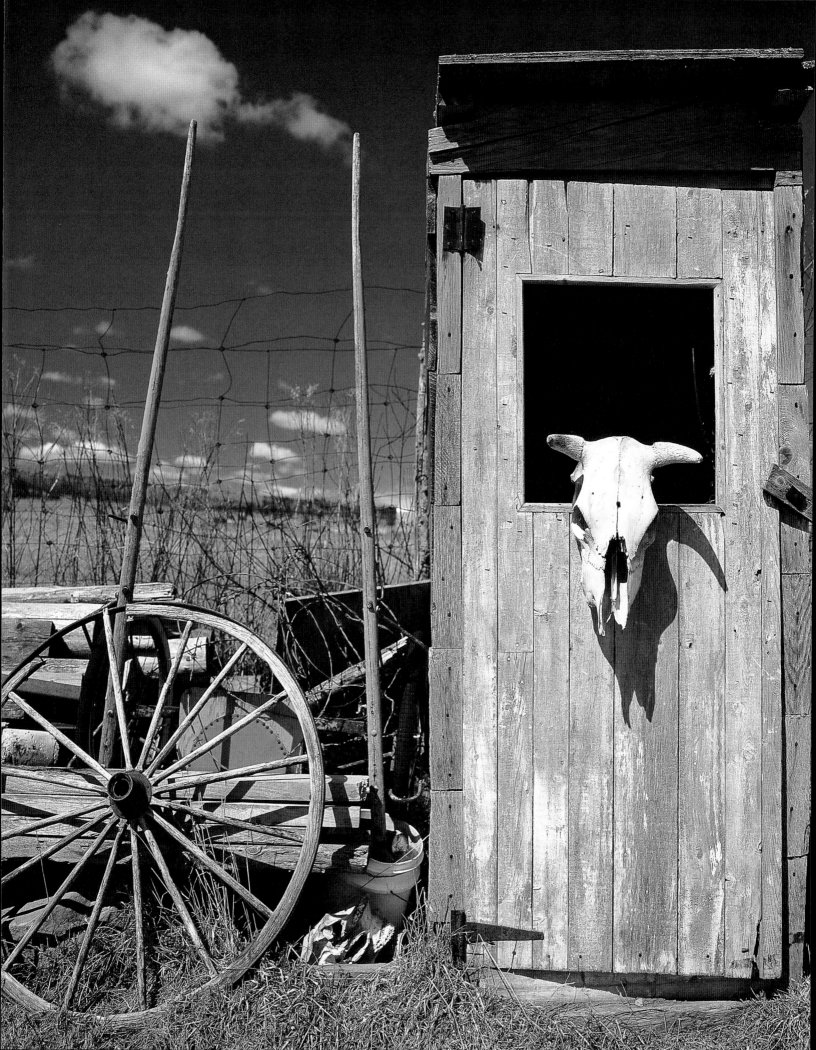

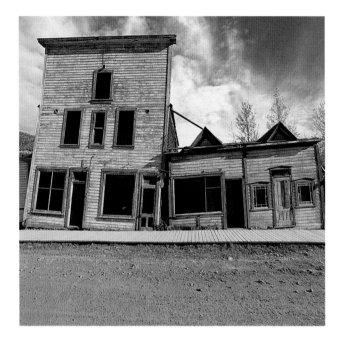

A rustic idyll. While the cowhand retires for a period of quiet study inside this classically simple and robust reading room, the loyal steed waits patiently with the brave and faithful dog. The cowhand ensures the steed's docility in the face of unexpected concussions, percussions and repercussions by prudently taking the halter inside with him.

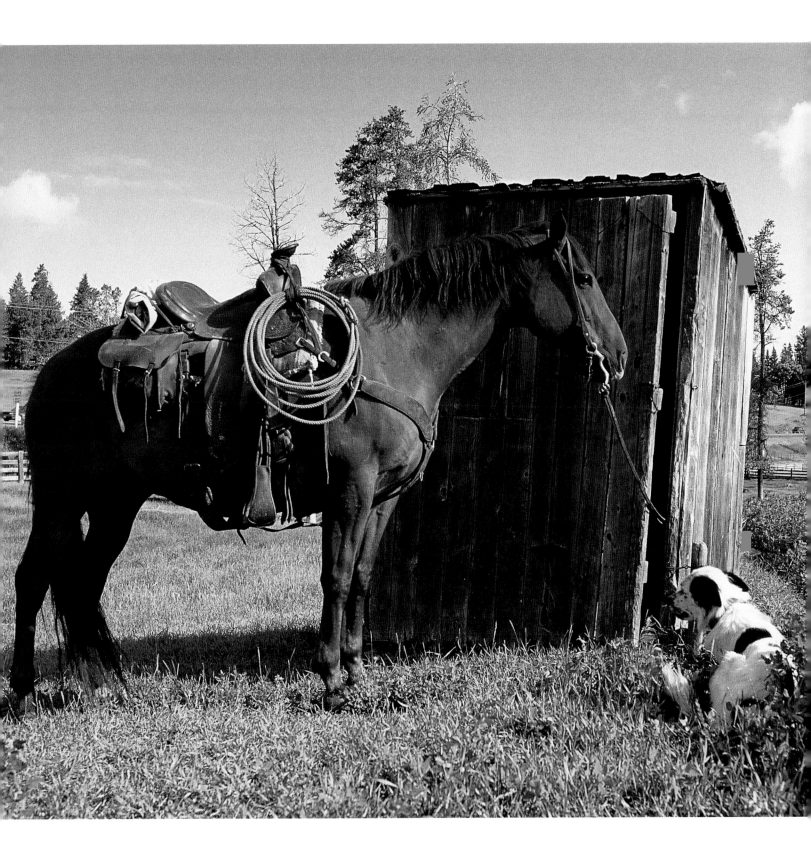

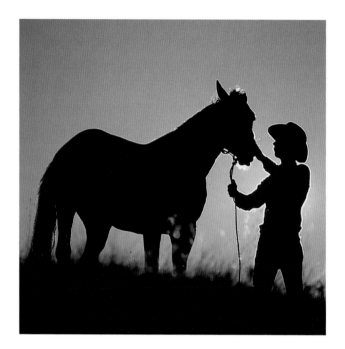

The rails of the corral fallen, the outhouse stands alone against the setting sun. Can the future bring us inventions which so fully and honorably discharge their essential functions? Inventions of which we think and speak with such fondness? Gallant little shed, you were a relief to the feet, a vent for the feelings, an oasis of calm in the fury of a pioneer life. We respect you: we honor you. Hail and farewell!

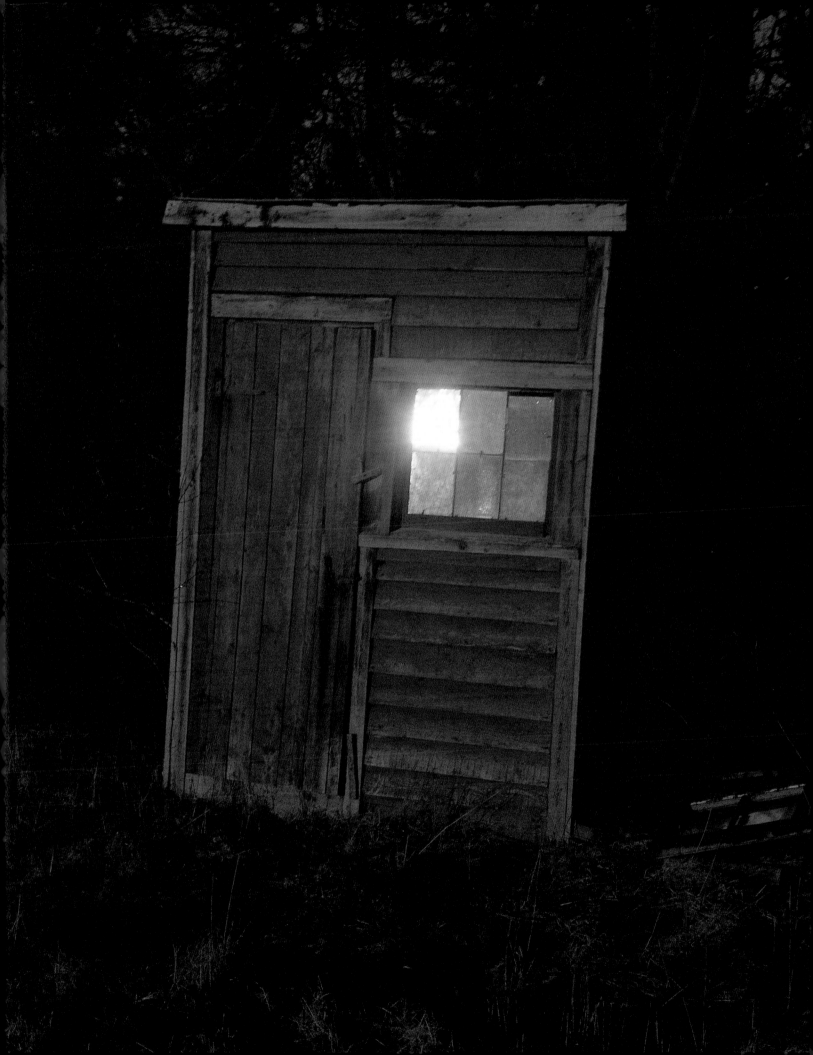